ANGLO-SAXON ILLUMINATION

IN

OXFORD LIBRARIES

BODLEIAN LIBRARY · OXFORD

Bodleian Picture Books
Special Series No. 1

© BODLEIAN LIBRARY 1970

FIRST PUBLISHED 1970

SBN 900177 06 3

PRINTED IN GREAT BRITAIN
AT THE UNIVERSITY PRESS, OXFORD
BY VIVIAN RIDLER
PRINTER TO THE UNIVERSITY

PREFACE

THE period of English illumination covered in this booklet starts with the reign of Alfred the Great (871–99) and extends to the end of the eleventh century, the aftermath of the Conquest of England by the Normans in 1066. The majority of the manuscripts illustrated were made in monastic scriptoria and most of them are religious or liturgical texts.

The main historical factors contributing to their production are royal patronage and a revival of monasticism. In addition to Alfred's own work as translator and restorer of learning (Pl. 1a, b), we know of books presented to various monasteries by Kings Athelstan (Pl. 1c), Edgar, and Cnut, all of whom are represented in Anglo-Saxon miniatures. The small Gospel lectionary (Pls. 26–9) belonged to Margaret, queen of Scotland (d. 1093), who was by birth an Anglo-Saxon princess, grand-daughter of Edmund Ironside, though it was probably not made for her. The most important of the leaders of the remarkable monastic revival in tenth-century England were St. Dunstan (abbot of Glastonbury c. 943–57, archbishop of Canterbury 961–88; represented in Pl. 6), St. Æthelwold (monk of Glastonbury under Dunstan, abbot of Abingdon, bishop of Winchester 963–84), and St. Oswald (bishop of Worcester 961, archbishop of York 972–92).

There was close and repeated contact between England and the Continent during this period. Both Dunstan and Oswald travelled, the first spending his exile at Ghent and the second visiting S. Benoît-sur-Loire (Fleury). Royal marriages also resulted in the exchange of gifts and a number of continental manuscripts received as presents by Athelstan were given by him to monasteries (Pl. 5).

The earliest illumination shown (Pl. 1) is dependent on earlier insular models, though the initials are much more modest in scale than those in the Barberini Gospels (Vatican, Barb. lat. 570) or the British Museum Bede (Cotton Tiberius C. II), examples of the type of southern English late eighth-century illumination from which they ultimately derive. Interlace pattern, one of the main ingredients of insular style, continues to be used but the interlace is combined with small beasts and birds shown either complete or as heads with snapping jaws and beaks (Pls. 1–4, 12–14). The interlace is not constrained in panels as in the insular books but is used to give a sense of movement and vigour which is characteristic of all Anglo-Saxon painting of the time. A curling leaf scroll deriving from

3

Eastern sources introduces an impression of movement in three dimensions and is often twisted into shape to form the initials (Pl. 2*b*). One manuscript has quite exceptional initials composed of gymnastic figures which are a remarkable anticipation of later Romanesque initials (Pls. 3*a*, 4).

For the miniatures the sources are different. Here we see the artists copying, and in the process altering, models in which elements of the illusionistic style of the classical period had been preserved to a greater or lesser degree. Thus the miniatures added to the Athelstan Psalter probably depend on a Mediterranean model of the sixth or the seventh century, as suggested by the sombre colour, the two-tier space, and the sharp profile heads (Pl. 1*c*). Such early models survived in England (an Italian Gospel book of the late sixth century, traditionally brought over by St. Augustine, still exists at Corpus Christi College, Cambridge) and acted as a stimulus to artists right into the Romanesque period. Early models were also copied by Carolingian artists of the ninth century and in some cases antique originals were transmitted to England via these copies.

The influence of the Carolingian Renaissance can also be seen in script since from the mid tenth century the round Carolingian minuscule gradually replaces the native forms (cf. Pls. 2*b*, 3*b* with Pls. 13, 25*b*). At the same time the existence of a flourishing vernacular literature serves to emphasize English independence as well as English artists' ability to create new types of representation (Pl. 17).

The manuscript associated with St. Dunstan mentioned above contains one of the earliest examples of what became an English speciality, outline drawing (Pl. 6). Here the stylistic source has been suggested to have been art of the Emperor Charlemagne's Court School, ivories and perhaps manuscript illumination, although only painted miniatures of this school survive. The arrival at Canterbury by the late tenth century of the Psalter made at Rheims *c.* 820 (now in Utrecht), which is illustrated entirely with pen drawings, seems to have given an impetus to Anglo-Saxon artists, and its flickering line and excited movement are reflected, for example, in the second group of drawings in the Caedmon (Pl. 18; cf. also Pl. 9). Other Anglo-Saxon drawings of the late tenth century are a development of the Dunstan drawing style (Pls. 6, 7) in which the folds become more complicated and the figures less monumental (Pl. 11), until in the eleventh century the two styles fuse and the line appears to freeze into harder, sharper forms (Pls. 21–2).

For the painted miniatures of the third quarter of the tenth century, of which the Benedictional of St. Ethelwold (now in the British Museum, Add. MS. 49598) is the outstanding representative, the Carolingian Schools

associated with Drogo, archbishop of Metz (826–55), and the Emperor Charles the Bald (823–77) are probably the stylistic source. In the early eleventh century this style, of which there is a single example in the Bodleian (unfortunately retouched, Pl. 23), developed in the directions of even greater impressionistic effect. The highlights and colour gradations in painted miniatures give the same restless effect as the shivering line of the drawings (Pls. 24, 26–9). Bands of darker colour in the drapery serve not to model form as in classical painting, nor to stress the parts which make up the whole as in Romanesque painting, but to emphasize surface pattern and movement.

Opposed to this is the style of a few manuscripts of the mid century in which the more sculptural and defined qualities of the Romanesque style seem to be foreshadowed. It is difficult to be sure to what extent this process appeared before the Conquest since so few manuscripts can be securely dated from internal evidence. Certainly the Romanesque style had proceeded further on the Continent, and, even if the process had already begun in England, the effect of the Conquest must have been to accelerate it. The Normans were already using forms of decoration, especially the inhabited scroll and the historiated initial, and a new spatial organization, which are typical of the Romanesque period (cf. *English Romanesque Illumination*, Bodleian Picture Book no. 1). Though the new style, which like all North French illumination owed much in its origins to Anglo-Saxon art, predominated in some English centres, there were survivals of the old style in others (Pls. 31–6), and the outline drawing style can still be found in England in the early twelfth century.

Acknowledgements. Acknowledgement is made to the Provost and Fellows of Oriel College, the President and Fellows of St. John's College, and the Warden and Fellows of Wadham College for permission to reproduce manuscripts in their libraries. I should also like to thank Dr. A. C. de la Mare, Dr. R. W. Hunt, Professor O. Pächt, and Professor F. Wormald for reading over this text and making various corrections and suggestions.

J. J. G. ALEXANDER

DESCRIPTION OF PLATES

Manuscripts are reproduced actual size, unless indicated on the plate by a fraction showing the proportional reduction. Measurements given below are of the whole page

1*a, b*. MS. Hatton 20 (S.C. 4113). 270 × 220 mm. Gregory the Great, Cura Pastoralis. Version in West Saxon by Alfred the Great (849–899). *c*. 890–7.

a. Fol. 28. Initial 'B'. *b*. Fol. 57ᵛ. Initial 'A'.

This copy of the translation can be dated *c*. 890–7 and was presented to Werferth, bishop of Worcester. The initials form a link between late eighth-century English work (e.g. the Barberini Gospels, Vat. Barb. lat. 570) and later Anglo-Saxon initials. The interlace and the animal heads may be compared with Pls. 2–4, 12–14. Orange, yellow, green, and black are the colours used.

1*c*. MS. Rawl. B. 484, fol. 85. 113 × 92 mm. Cutting from a Psalter. Second quarter of the 10th century.

The Nativity is shown above, with, below, the two midwives washing the infant Jesus. This miniature was part of the additions made to a small ninth-century continental Psalter traditionally given to the Old Minster, Winchester by King Athelstan (924–39), now London, British Museum, Cotton MS. Galba A. XVIII. The miniatures were no doubt executed at that date. The miniature may be compared with Pl. 2*b* for its style (profile faces). It originally preceded Psalm I (the offprint of the initial 'B' on fol. 35 of the Cotton MS. is seen at the top). It is thus the earliest example of the adoption of a scene from Christ's Life as a prefatory miniature in a Psalter. This practice later became very common in England and was then adopted elsewhere. The earliest extended cycle is in another Winchester Psalter, British Museum, Cotton MS. Tiberius C. VI of the mid eleventh century.

It is not known when the miniature was detached from the Psalter. A note dating it to the ninth century is written by Sir James Ware (1594–1666), the Irish antiquary, many of whose manuscripts later came into Rawlinson's hands.

2. MS. Junius 27 (5139). 242 × 172 mm. Psalter in Latin with Old English interlinear gloss (the Junius Psalter). Second quarter of the 10th century.

The manuscript is related in script and decoration to manuscripts made at Winchester in the first half of the tenth century (cf. Pl. 1*c*). The colouring of the initials in blue, green, brown, pink, and yellow is very rich. The manuscript belonged to Queen Christina of Sweden, then to Isaac Vossius, and finally to Francis Junius, who gave it to the Bodleian.

a. Fol. 118. Initial 'D'. The pose of David kneeling on the lion's back goes back to that used in the classical period in representations of Mithras slaying the bull.

b. Fol. 135ᵛ. Initial 'N'. The majority of the initials are made up, as here, of plant scroll, interlace, and animal or human heads.

c. Fol. 112ᵛ. Initial 'C'. Other initials are historiated with bust figures, a type of initial of which the earliest example is in an English manuscript of the eighth century, the Leningrad Bede.

3*a*. MS. Tanner 10, fol. 115ᵛ. 245 × 165 mm. Bede, Ecclesiastical History of the English People. In Old English. Initials 'Þa ae(fterfylgde)'. First half of the 10th century.

The manuscript belongs in style to the first half of the tenth century. Most of the initials, unlike those shown here, are painted in orange, yellow, and green. In addition to the remarkable gymnastic initials there are the more normal types with animals, birds, and plant scroll. The way that several letters of the opening word or words are decorated, not just the initial, recalls insular manuscripts of the seventh–eighth century. See also Pl. 4.

3*b*. MS. Bodley 579 (S.C. 2675), fol. 154ᵛ. 195 × 145 mm. Sacramentary (the 'Leofric Missal'). Initial 'E'. Mid 10th century.

Drawn in pen, the initial is made up of interlace, dragons, and a human head. It is one of the earlier additions made in England in the mid tenth century to a Carolingian Sacramentary of the second half of the ninth century made for use in the diocese of Arras/Cambrai. For the later additions, see Pls. 9–10.

4. MS. Tanner 10. Bede, Ecclesiastical History. First half of the 10th century. The pages have been cut down by later binding. See also Pl. 3*a*.

a. Fol. 68. Initials 'Þy ge(myndgadan)'. The initials and opening letters are painted orange, green, pink, brown, and yellow.

b. Fol. 93. Initial 'Þ'. Two dragons and a gymnastic figure make up the initial. They are painted in yellow, brown, green, and orange.

c. Fol. 38. Initial 'O' with a symmetrical design of beasts and leaves.

5. St. John's College, Oxford, MS. 194, fol. 1ᵛ. 164 × 123 mm. Gospels. Mid 10th century.

The portrait of St. Matthew was added in the mid tenth century on a flyleaf of the original ninth-century Gospels, which was perhaps written in Brittany. It is copied from the miniature of St. Matthew in a Gospels made for Lobbes near Liège in the late ninth–tenth century, now British Museum, Cotton Tiberius A. II. That manuscript was probably presented to King Athelstan by Otto I of Germany and given by Athelstan to Christ Church, Canterbury. The St. John's College Gospels was very probably also at Christ Church in the Middle Ages. There are touches of green wash on the curtains and St. Matthew's undergarment. Otherwise the drawing is in brown ink. It has been retouched (the head of the angel's staff, the cloak on St. Matthew's right shoulder, the script on the lectern). This retouching was presumably done when the miniature of King Edward the Confessor was added on the recto opposite, i.e. fifteenth century (?).

There are faint traces of Evangelist portraits drawn in pencil on fols. 20ᵛ and 31ᵛ, probably in the ninth century.

6. MS. Auct. F. 4. 32 (S.C. 2176), fol. 1. 245 × 179 mm. 'St. Dunstan's classbook' —a miscellany, partly grammatical, put together *c.* 1500. Mid 10th century.

The drawing represents St. Dunstan at the feet of Christ 'Logos' as figure of wisdom. The inscription in the first person may have been written by St. Dunstan himself (abbot of Glastonbury *c.* 943–57, archbishop of Canterbury 961–88). He is known to have been an artist and the drawing may also be by him. Its stylistic sources are to be sought in the art of the Court school of Charlemagne of *c.* 800 (e.g. ivories such as that on the cover of Bodleian Library, MS. Douce 176 (black and white postcard no. 119)). The only colour is orange, used for Christ's halo and in a few other places.

7. St. John's College, Oxford, MS. 28, fol. 2. 328 × 237 mm. Miscellaneous texts by Dionysius Areopagita, etc. Mid 10th century.

The drawing represents Christ and is in reddish-brown ink. It is on what seems to have been originally a blank flyleaf. Around and partly over it at a later date, perhaps late tenth century, the Passion of Sts. Peter and Paul has been written, fols. 1–4, 7, 78–81. For the manuscript to which these leaves were added see Pl. 14*a*, *b*.

The drawing is an outstanding example of the earliest stage of outline drawing in England (cf. Pl. 6) and is of the mid tenth century.

8. St. John's College, Oxford, MS. 28, fol. 81ᵛ. Mid 10th century.

Sketches on an end-leaf. Professor Wormald has suggested that the first standing figure (above left) may possibly be a Person of the Trinity as in the Carolingian drawing from Lorsch (Vatican library, Pal. lat. 834). The second figure (above right) is another version of the same figure drawn in red ink.

The third figure (below left) is an angel and Miss Raw has suggested that the objects held out represent 'Day' and 'Night'.

On the recto of this folio is an invocation to St. Vincent in an early twelfth-century hand, which perhaps means that the manuscript was then at Abingdon.

9. MS. Bodley 579 (S.C. 2675), fol. 49. Sacramentary (the 'Leofric Missal'). Before 979 (?).

A calendar and computistical tables were added in England to the ninth-century continental Sacramentary (for which see Pl. 3*b*). The calendar is for use at Glastonbury and, since King Edward martyr is not included, it was probably written before 979. Later the manuscript was given to Exeter cathedral by Leofric, bishop from 1046 to 1072.

Unfortunately the drawings are very faint and difficult to reproduce. They are in blue, red, and green inks, apparently the earliest English example of this technique which becomes quite common in later Anglo-Saxon drawings, particularly in Canterbury manuscripts (cf. Pl. 18). It is not necessarily an English invention, however, for in a ninth-century Bede from Lorsch (Vatican library, Pal. lat. 834) there is a drawing of the Trinity, in which two Persons are in brown ink and the third in blue.

The present drawings already show the influence of the ninth-century Rheims style with its flickering line. The outstanding example of this style, a Psalter, now at Utrecht, was at Canterbury at least by the late tenth century, since a copy made there still survives (British Museum, MS. Harley 603).

The 'Paschal Hand' diagram is connected with the calculation of Easter. Two small figures are to left and right. The inscription reads: 'Dextera nam domini fulget cum floribus Paschae'.

10. MS. Bodley 579 (S.C. 2675). Sacramentary (the 'Leofric Missal'). Before 979 (?).

a. Fol. 49ᵛ. 'Vita'. *b*. Fol. 50. 'Mors'.

The two figures, also in red, blue, and green ink, have been elucidated by Dr. Heimann. They illustrate the so-called 'Sphaera Apulei', a text giving a calculation by which a patient could know if he would live or die. 'Vita' is represented as a King, the Lord of Eternal Life (though without halo), whilst 'Mors' is ultimately based probably on some late Egyptian hybrid god such as Bes Pantheos, often represented on amulets and in small bronzes. The six dragons flanking the head of 'Mors' represent the six sons of Death described in Coptic texts also from Egypt.

11. MS. Bodley 577 (S.C. 27645). 200 × 140 mm. Aldhelm, de virginitate. *c.* 1000.

a. Fol. 1. The miniature shows a haloed figure with a reading-desk and presumably represents Aldhelm. It is modelled on an Evangelist portrait from a Gospel book and closely resembles the St. Mark in the tenth-century Anglo-Saxon Gospels now in the Chapter Library, York.

Mr. T. A. M. Bishop has attributed the manuscript to the Christ Church, Canterbury, scriptorium. The drawing style, as was pointed out by Professor Wormald, is close to that of the second hand of the Prudentius, British Museum, Cotton Cleopatra C. VIII which also belongs to Mr. Bishop's Canterbury group. The date is the turn of the tenth to the eleventh century. The drawing is in ink and the patches of colour seem to be very much later additions. The page is unfortunately badly stained and there is a show-through from the verso.

b. Fol. 1ᵛ. Aldhelm is shown presenting his book to the nuns of Barking, to whom it is dedicated. A similar scene is shown in another Aldhelm, Lambeth Palace MS. 200, where, however, Aldhelm is seated.

12a. MS. Bodley 718 (S.C. 2632), fol. 24. 326 × 204 mm. Penitential of Egbert, archbishop of York. *c.* 1000.

Initial 'V'. The initial is typical of a group of Anglo-Saxon manuscripts of the late tenth to early eleventh century, many of which come from Canterbury (Pl. 12*b*, 13, 14). The present manuscript was perhaps intended for or even made at Exeter. St. Felix occurs in the litany and King Athelstan had given a relic of Pope Felix martyr to Exeter.

The interlace has a 'wiry' appearance and there are many snapping beast and bird heads. The initials develop the style already seen in the Junius Psalter (Pl. 2). The drawing is in black and pale orange and there are touches of green.

12b. MS. Rawl. C. 570, fol. 2. 205 × 161 mm. Arator, Historia apostolica. *c.* 1000.

Initial 'M'. The manuscript appears in the catalogue of St. Augustine's, Canterbury, in the late fifteenth century and it was probably made there. The initials are drawn in brown ink, the rubrics and minor initials are in green and orange.

13. MS. Auct. F. 1. 15 (S.C. 2455), fol. 16. 375 × 250 mm. Boethius, de consolatione philosophiae, Persius, Satires. *c.* 1000.

Initial 'P'. This manuscript was also probably written at St. Augustine's, Canterbury. The illuminated initials, drawn as usual in brown ink with touches of orange and green, belong to the same group as those illustrated on pls. 12 and 14. The manuscript was later given to Exeter by Leofric, bishop 1046–72. It is a particularly large and splendid copy.

14a, b. St. John's College, Oxford, MS. 28. Dionysius Areopagita, etc. *c.* 1000.

a. Fol. 26. Initial 'A'. *b.* Fol. 27. Initial 'A'.
The initials in this volume (for which see Pls. 7–8) are drawn in red, brown, and green ink and belong to the same group as those in Pls. 12–13.

14c. Oriel College, Oxford, MS. 3, fol. 6. 317 × 205 mm. Prudentius, Peristephanon, Cathemerinon, etc. *c.* 1000.

The initial 'P' is drawn in black pen with touches of brown. Again there are only animal heads, not the full bodies. The style again links the initial with the Canterbury group and Mr. Bishop has identified the main scribe with the scribe who wrote the text of the Aldhelm from Christ Church (Pl. 11).

15. MS. Junius 11 (S.C. 5123), p. 3. 318 × 195 mm. 'Caedmon' Genesis, etc. In Old English. Early 11th century.

The drawings of this manuscript divide into two groups, the first on pp. 1–68, the second from pp. 73 to 88, after which spaces for the illumination are left blank. There are a number of pages missing at the beginning of the manuscript. The present page shows the rebellion of Satan and his downfall. It is a pen and wash drawing in red and dark-brown inks.

On p. 2 is a medallion with a bust head labelled Ælfwine. This has been thought to represent Ælfwine who became abbot of New Minster, Winchester, in 1035, but this seems unlikely, since the manuscript is probably to be identified with one described in the thirteenth-century catalogue of Christ Church, Canterbury. More recently Mme M.-M. Larès has suggested that it may be the Atheling of Northumbria killed in 679 who is represented. If that is so, the resemblance to certain Anglo-Saxon coin types would be relevant.

Though the manuscript copies an earlier prototype both in miniatures (see Pl. 16) and initials, it belongs probably to the early eleventh century. Certain stylistic features found on datable eleventh-century Scandinavian monuments (see Pls. 19–20) are probably derived from England rather than vice versa, and do not, therefore, indicate a mid-century date for the manuscript as has been supposed.

16. MS. Junius 11, p. 11. Early 11th century.

The miniature shows God blessing Adam and Eve in the Garden of Eden. The figure of God is painted with an olive-green overmantle and a brown undermantle. This colour scheme recalls earlier manuscripts of the first half of the tenth century (cf. Pls. 1c, 2) and it is likely that these illustrations go back to a model of that date.

17. MS. Junius 11, p. 61. Early 11th century.

The scene is the Translation of Enoch. Enoch is shown accompanied by two angels below. Above he is shown vanishing into the clouds. This system of continuous narration by which the passing of time is suggested by repeating a figure in the manner of a strip cartoon, is a narrative device of the Antique period and shows that the artist had much earlier models available to him for his miniatures. The Enoch scene may have influenced Anglo-Saxon artists in their portrayal of the Ascension in the type of the so-called 'disappearing Christ', where also only Christ's feet and legs are shown as he rises into Heaven.

18. MS. Junius 11, p. 82. Early 11th century.

The miniature shows the building of the Tower of Babel and the dispersion of the children of men. Dr. Henderson has pointed out similarities with the cycle of the 'Cotton' Genesis, a fifth-century illustrated Genesis, which again suggests an ultimate dependence on early Christian models.

The miniature belongs to the second group of drawings which are made in blue, red, and green inks (cf. Pls. 9–10). The artist is the same as in a Prudentius at Cambridge, Corpus Christi College, MS. 23, which was early at Malmesbury. The illustrations there are also in coloured inks.

19. MS. Junius 11, p. 225. Early 11th century.

This drawing, whose purpose is uncertain, occurs in a space towards the end of the manuscript. Sometimes thought to be a design for a binding, it might also be for a piece of metalwork or even embroidery.

20. MS. Junius 11, p. 230. Early 11th century.

These two sketches occur on the last flyleaf verso of the manuscript. Both drawings show connections with the Scandinavian 'Ringerijke' style in their angular forms, as do many of the earlier miniatures in the manuscript.

21. MS. Bodley 155 (S.C. 1974), fol. 93ᵛ. 260 × 198 mm. Gospels. Early 11th century.

Instead of the usual author portraits the manuscript contains two drawings of seraphim. They are fairly close in design to the Three Persons of the Trinity in the Sherborne Pontifical (Paris, Bibliothèque nationale, latin 943) of *c.* 992–5, but are slightly later in date, and may be assigned to the early eleventh century. The drapery folds are becoming sharper and more corrugated. In the twelfth century the manuscript belonged to Barking Abbey.

The angel preceding the Gospel of St. Luke is drawn in black and brown ink and bears a scroll with the words 'Fuit in diebus herodis regis Judaeae sacerdos' (Luke 1: 5). The iconography has not been explained, but perhaps the angel refers to the Annunciation to Zacharias. This scene sometimes introduces St. Luke's Gospel (e.g. London, British Museum, Harley MS. 2788, early ninth century, and Bodleian Library MS. Auct. D. 2. 15, twelfth century, *Bodleian Library Picture Book*, no. 1, pl. 14), and the initial 'F' of verse 5 is quite often stressed with a painted initial in addition to the opening initial 'Q' of verse 1.

On fol. 1 the antiquary, Stephen Batman (d. 1584), has sketched another angel on a replacement leaf, which possibly copies a missing original.

22. MS. Bodley 155 (S.C. 1974), fol. 146ᵛ. Early 11th century (?).

The angel preceding St. John holds a scroll. This has been inscribed by a sixteenth-century hand (possibly Stephen Batman) 'Credo videre bona Domini in terra viventium' (Psalm 26: 13). The drawing is in black and brown ink. The figure from fol. 93ᵛ (Pl. 21) has here been moved up into the centre of the frame to make a centralized composition typical of many Anglo-Saxon miniatures (cf. Pl. 23). The hand of the Lord is placed above, which also suggests an adaptation of the independent figure of fol. 93ᵛ. The drapery is here more agitated and the figure less static. Whether this difference of style means that this drawing is a slightly later addition by a different hand, or whether the figure on fol. 93ᵛ looks earlier because it retains more of an earlier model, is difficult to say.

23. MS. Tanner 3, fol. 1ᵛ. 271 × 170 mm. Gregory the Great, Dialogues. First quarter of the 11th century.

The scene is of Pope Gregory the Great in conversation with Petrus the interlocutor of the Dialogues. Unfortunately the miniature has been retouched (St. Gregory's face and tunic, the right-hand curtain, some of the panel fillings, etc.). It is comparable in style to the Sacramentary of Robert of Jumièges now in Rouen, and probably belongs to the first quarter of the eleventh century. Note the typically Anglo-Saxon corner rosettes. The colours are blue, olive-green, orange-red, and pale pink. The manuscript contains a twelfth-century list of books, possibly from Worcester cathedral, and a copy of a papal letter to a bishop of Worcester.

24. MS. Douce 296 (S.C. 21870), fol. 40. 264 × 160 mm. Psalter. Second quarter of the 11th century, before 1036 (?).

The Psalter has a calendar suggesting it was made for use at Crowland in the Fens, and the entry for Ælfred, brother of Edward the Confessor (d. 1036), is an addition. The miniature of Christ treading upon the beasts illustrates the words of

Ps. 90 v. 13.: 'Thou shalt tread upon the lion and the adder . . .'. The iconography is based on the ancient Egyptian representation of the God Horus. It occurs on the eighth-century carved stone Bewcastle and Ruthwell Crosses and in a number of Anglo-Saxon Psalters of the tenth–eleventh centuries. Here it precedes Psalm 51, marking the threefold division which is a common feature of Insular Psalters. The colours used are blue, green, white, pale orange, and gold.

25. MS. Douce 296 (S.C. 21870). Second quarter of the 11th century. Before 1036 (?).

a. Fol. 9. The large initial 'B' introducing Psalm 1 has a lion mask joining the bows of the letter as in a number of Anglo-Saxon examples (e.g. London, British Museum, Harley MS. 2908). We have already seen an early example, Pl. 1*b*.

b. Fol. 40ᵛ. In the initial 'Q' which introduces Psalm 51 a figure, apparently in chain mail, fights the dragon which makes up the tail of the letter. No doubt this is intended to represent St. Michael, though he has no wings. The representation of St. Michael with a sword and not a spear is found in a number of English examples, but is otherwise uncommon at this date.

26. MS. Lat. liturg. f. 5 (S.C. 29744), fol. 3ᵛ. 172 × 110. Gospel lectionary ('St. Margaret Gospels'). Second quarter or mid 11th century.
St. Matthew is portrayed writing his Gospel. There is no Evangelist symbol. The colours used are red-brown, olive-green, blue, and gold. The style shows a development of that of the Douce Psalter (Pl. 24) and the date is the second quarter or mid eleventh century.
 A poem on a flyleaf written in the late eleventh century relates a miracle by which the manuscript was recovered undamaged after falling into a stream. Turgot in his life of St. Margaret of Scotland tells an identical story about her favourite Gospel Book. Margaret married Malcom Canmore of Scotland in 1067 and died in 1093, bequeathing a Gospel Book to Durham Cathedral which, it has been suggested, may be identifiable with the present manuscript. An entry in the Durham catalogue of 1383 may also refer to this manuscript, which then had a silver binding.

27. MS. Lat. liturg. f. 5, fol. 13ᵛ. St. Mark. Second quarter or mid 11th century.

28. MS. Lat. liturg. f. 5, fol. 21ᵛ. St. Luke. Second quarter or mid 11th century.

29. MS. Lat. liturg. f. 5, fol. 30ᵛ. St. John. Second quarter or mid 11th century.

30. MS. Bodley 775 (S.C. 2558), fol. 8. 268 × 165 mm. The 'Æthelred Troper'. Mid 11th century.
The Troper was written at the Old Minster, Winchester, in the mid eleventh century, copying an exemplar of between 979 and 980. The rather simple 'O' introducing the tropes for Advent is composed of interlace and colour panels and is related to ninth-century North French initials of the so-called Franco-Saxon school.

31. Wadham College, Oxford, MS. 2, fol. 12ᵛ. 205 × 141 mm. Gospels. Late 11th century.
St. Matthew holds a scroll in front of him and a pen in his right hand. The drawing is in red ink. It copies an earlier model very similar to and perhaps identifiable as the 'Grimbald Gospels' from New Minster, Winchester, of the late tenth

century (British Museum, Add. MS. 34890). The frames, the curtain, and the Evangelist's pose can all be compared. The script is Norman rather than English in form and suggests a date in the late eleventh century, so this again is an example of the survival of Anglo-Saxon style.

32. Wadham College, Oxford, MS. 2, fol. 13. Late 11th century.

On fol. 13 is a similar frame but gilded and coloured, containing the title and opening words of St. Matthew's Gospel which continues on the verso. In the centre a faint pencil sketch is barely visible. It is here reproduced from a photograph taken by ultra-violet light and is clearly very similar to the portrait on fol. 12v (Pl. 31). The feet are not crossed on fol. 13. The dancing pose of the feet on fol. 12v, found in so many Romanesque sculptures, perhaps suggests that it is the later of the two. At any rate some change of plan has taken place.

33. Wadham College, Oxford, MS. 2, fol. 104v. Late 11th century.

The three Maries are shown approaching the Tomb from the right. An angel sits by the grave with three soldiers asleep below. The drawing is again in red ink.

This is the scene used in the West to represent the Resurrection of Christ until the twelfth century. The inconography is very close to that of the same scene in the Benedictional of St. Ethelwold (British Museum, Add. MS. 49598), as Professor Talbot Rice noted. The use of two different models from Winchester suggests that the present Gospels was made there too.

The subject is unusual in a Gospel book, and so is its position preceding the Prologue of St. John, not the Gospel text itself. There is a third frame on fol. 42v also in red ink but the miniature inside was never drawn. It precedes St. Mark's Gospel, of which the prologue is missing. It seems likely that the illustrations were not part of the original plan of the book and were never completed.

34. Wadham College, Oxford, MS. 2. Late 11th century.

a. Fol. 3. Initial 'B'. The initial is painted in green, blue, and brown and the outline is gold. It introduces Jerome's preface to Pope Damasus. Again it has the lion mask (cf. Pls. 1*b*, 25*a*).

b. Fol. 67. Initial 'Q'. The initial is in red ink. It introduces St. Luke's Gospel. The angel is a copy by a weaker but no doubt contemporary hand of the angel on fol. 104v (Pl. 33). Other initials also drawn in red ink but without figures are on fols. 43, 103, and 103v.

35. MS. Bodley 130 (S.C. 27609), fol. 26. 244 × 180 mm. Latin Herbal of Sextus Apuleius with extracts from the Greek Herbal of Dioscorides translated into Latin. *c.* 1100.

The medicinal properties of the various plants are listed. The present folio shows the blackberry which is used to cure (among many other things!) cardiac complaints. The drawings derive from a classical tradition of naturalistic representation traceable as early as the fourth century B.C. Plant drawings on papyrus survive from the second century A.D.

The editors of the text consider MS. Bodley 130 to depend on a seventh-century version of the text, and the classical models of the illustrations have been considerably modified. Stylistic considerations suggest that a late tenth-century Anglo-Saxon manuscript was the immediate prototype of the present manuscript, which was written *c.* 1100 probably at Bury St. Edmunds. It bears the abbey's pressmark and *ex libris* of the late fourteenth century.

36. MS. Bodley 130 (S.C. 27609). *c.* 1100.

a. Fol. 91ᵛ. The Eagle (Aquila). *b.* Fol. 89. Capricorn.

The last text in the manuscript is concerned with the medicinal properties of animals and is ascribed to Sextus Placitus. The lively wash-drawings of birds and animals must copy a manuscript in the style of the well-known late tenth-century Anglo-Saxon Aratus (British Museum, Harley MS. 2506). A few subjects, like the Eagle, are painted.

Since the type of Anglo-Saxon script suggests a late date, *c.* 1100, this is another example of the Anglo-Saxon style surviving the Norman Conquest.

SELECT BIBLIOGRAPHY

BISHOP, T. A. M., 'Notes on Cambridge manuscripts. Part VI', *Transactions of the Cambridge Bibliographical Society*, iii. 5 (1963), 412–23.

FORBES-LEITH, W., *The Gospel Book of St. Margaret*. Edinburgh, 1896.

GOLLANCZ, I., *The Caedmon manuscript of Anglo-Saxon biblical poetry. Junius XI in the Bodleian Library*. Oxford, 1927.

GUNTHER, R. T., *The herbal of Apuleius Barbarus*. Roxburghe Club, 1925.

HEIMANN, A., 'Three illustrations from the Bury St. Edmunds Psalter and their prototypes', *Journal of the Warburg and Courtauld Institutes*, xxix (1966), 39–59.

HENDERSON, G., 'Late-antique influences in some English mediaeval illustrations of Genesis', *Journal of the Warburg and Courtauld Institutes*, xxv (1962), 172–98.

HOMBURGER, O., *Die Anfänge der Malschule von Winchester im X. Jahrhundert* (Studien über christliche Denkmaler, N.F. XIII). Leipzig, 1912.

HUNT, R. W., *St. Dunstan's Classbook from Glastonbury* (Umbrae Codicum Occidentalium, IV). Amsterdam, 1961.

KENDRICK, T. D., *Late Saxon and Viking art*. London, 1949.

KER, N. R., *Catalogue of manuscripts containing Anglo-Saxon*. Oxford, 1957.

—— *The Pastoral care* (Early English Manuscripts in facsimile VI). Copenhagen, 1956.

LARÈS, M.-M., 'Echos d'un rite hiérosolymitain dans un manuscrit du haut Moyen Age anglais', *Revue de l'histoire des religions*, clxv (1964), 13–47.

RAW, B., 'The drawing of an angel in MS. 28, St. John's College, Oxford', *Journal of the Warburg and Courtauld Institutes*, xviii (1955), 318–19.

RICKERT, M., *Painting in Britain, the Middle Ages* (Pelican History of Art), 2nd edn. Harmondsworth, 1965.

TALBOT RICE, D., *English art, 871–1100* (Oxford History of Art, 2). Oxford, 1952.

WORMALD, F., 'Decorated initials in English MSS. from A.D. 900 to 1100', *Archaeologia*, xci (1945), 107–35.

—— *English drawings of the 10th and 11th centuries*. London, 1952.

—— 'Anglo-Saxon initials in a Paris Boethius manuscript', in 'Essais en l'honneur de Jean Porcher', ed. O. Pächt, *Gazette des Beaux-Arts*, July–September, 1963, 63–70.

The Bodleian manuscripts will be included in O. Pächt, J. J. G. Alexander, *Illuminated manuscripts in the Bodleian Library, Oxford. III. English school*, in preparation.

INDEX OF MANUSCRIPTS

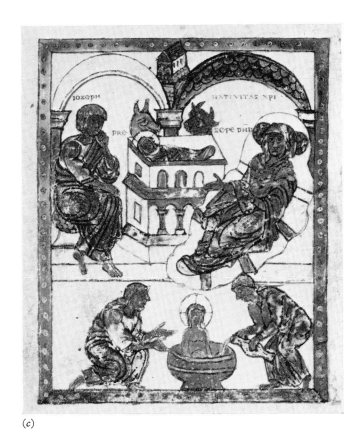

1 (a) Initial 'B': MS. Hatton 20, fol. 28 (b) Initial 'A': MS. Hatton 20, fol. 57ᵛ
(c) The Nativity of Christ: MS. Rawl. B. 484, fol. 85

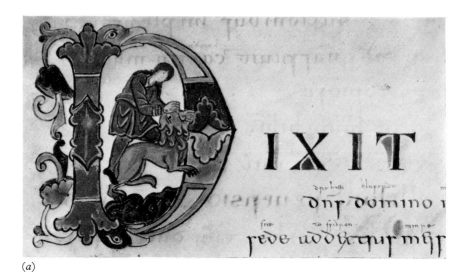

(a)

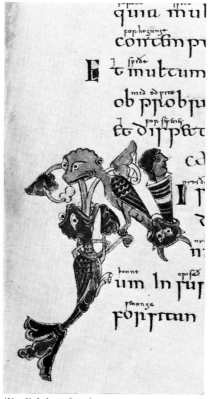

(b) slightly reduced

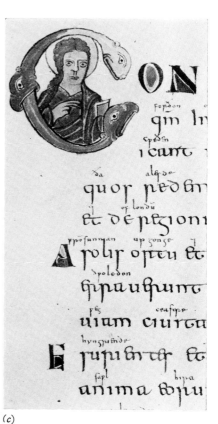

(c)

2 (a) Initial 'D' with David and the lion: MS. Junius 27, fol. 118 (b) Initial 'N': MS. Junius 27, fol. 135ᵛ (c) Initial 'C': MS. Junius 27, fol. 112ᵛ

(a) slightly reduced

(b) slightly reduced

3 (a) Initials 'Þa ae': MS. Tanner 10, fol. 115ᵛ (b) Initial 'E': MS. Bodley 579, fol. 154ᵛ

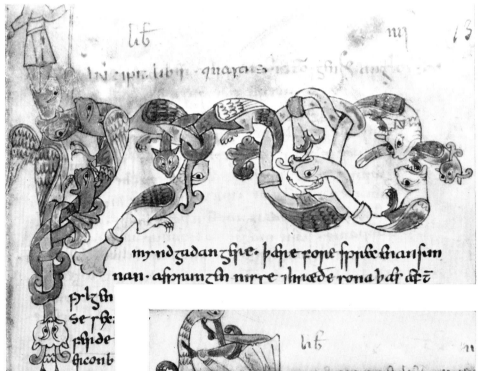

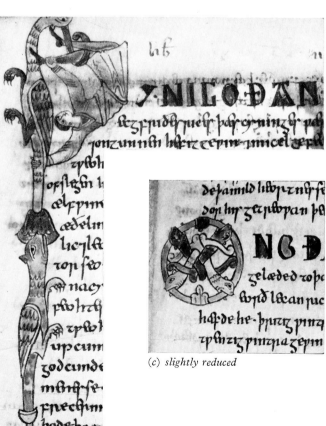

(a) *slightly reduced*

(b) *slightly reduced*

(c) *slightly reduced*

4 (*a*) Initials 'Þy ge': MS. Tanner 10, fol. 68 (*b*) Initial 'Þ': MS. Tanner 10, fol. 93 (*c*) Initial 'O': MS. Tanner 10, fol. 38

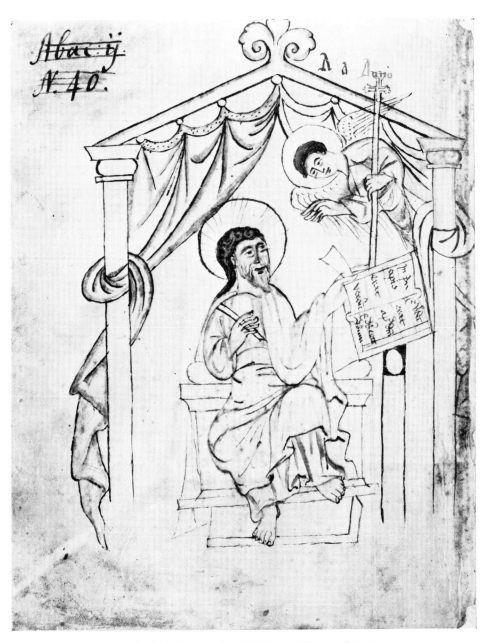

5. St. Matthew: St. John's College, MS. 194, fol. 1ᵛ

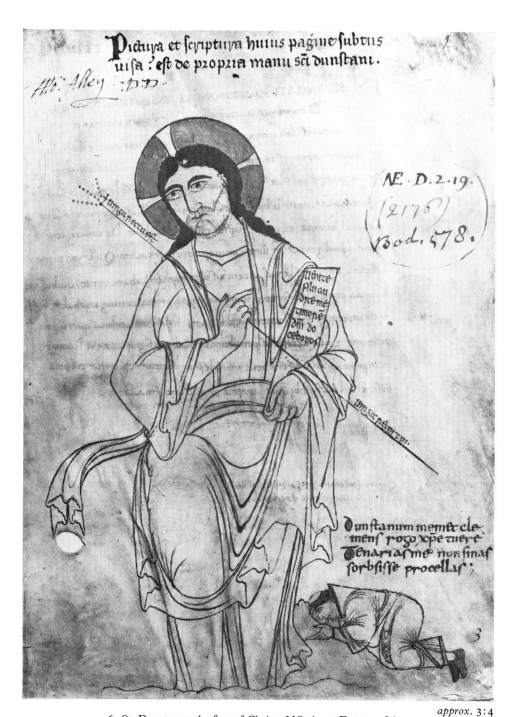

approx. 3:4

6. St. Dunstan at the feet of Christ: MS. Auct. F. 4. 32, fol. 1

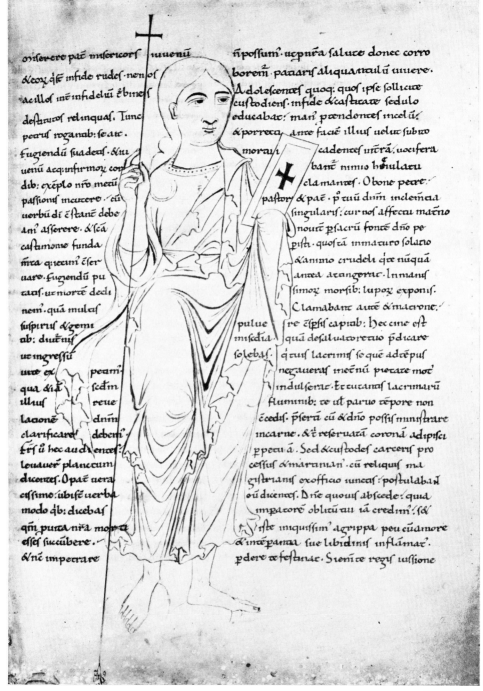

oñerere pat misericors iuuenū
&eoz qte inside rudes nen os
ac illos ī insidelū ē bine os
desstruros relinquas. Tunc
peaus roganab se eat.
fugiendū suadeas. & iu
uenū acq infirmoz cor
dib: exeplo nro meti
passionis meare cū
uerbū di ē stane debe
ani asserere. & sca
casamonie funda
mta q:ecū ēser
uare. fugiendū pu
caus ut morte deci
nem. quā mulas
suspiriis & gemi
ab: diutius
ut ingressū
uro ex peccami
qua dā sedm
illius reue
lacione dnm
clarificare deberi
tfsū hec audi entes
louauer plancum
dicentes. O pat uera
cissimo ubi ē uerba
modo qib: diceba
qm pura nra mot ā
esses succubere.
& ne impetrare

ñ possum. ut pnra saluto donec corro
boré paaaris aliqua tul ū uiuere.
Adolescentes quoq: quos ipse sollicite
custodiens inside & casticate sedulo
educabat: mari pandentes incel ū
& porreta ante facie illius uelut sub to
moraui cadentes ultra: uocifera
bant nimio hsulatu
clamantes. O bone petre
pastor & pat p tuū dūm inclemia
singularis: cur nos affectu matno
nout psacrū fonte dño pe
pisti. quos tā immaturo solacio
& animo crudeli qre nūquā
antea atangerat. In manus
simoz morsib: lupoz exponis.
Clamabant aute & matrone.
pulue re espsis capita: Hec cine est
miscdia quā desaluatore tuo pdicare
solebas. q tuis lacrimis se qué ad tepus
negauerat metnū pieate mot
indulserat. Et tu tantis lacrimarū
fluminib: te ut paruo tepore non
ecedis. psera cū & dño possis ministrare
incarne. & t reseruata corona adipisci
ppetu ā. Sed & custodes carceris pro
cessus & marciniani cū reliquis ma
gistrianis ex officio uneas: postulaba
oū dicentes. Dne quous abscede: quia
imparatore oblitū au iā credim. sd
iste iniquissim agrippa peu cū amore
& intepancia sue libidinis inflamat.
pdere te festinat. Si on te regis iussione

approx. 3:5

7. Christ: St. John's College, MS. 28, fol. 2

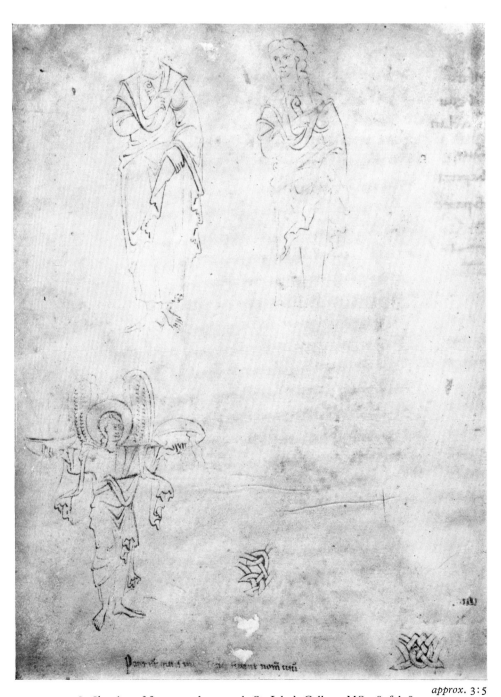

approx. 3:5

8. Sketches of figures and an angel: St. John's College, MS. 28, fol. 81ᵛ

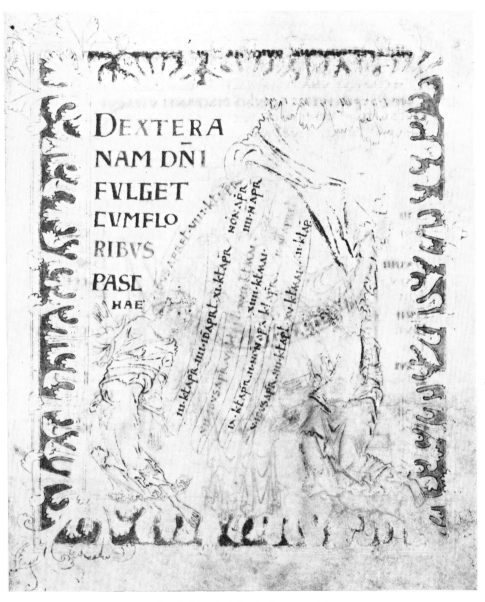

9. Paschal hand: MS. Bodley 579, fol. 49

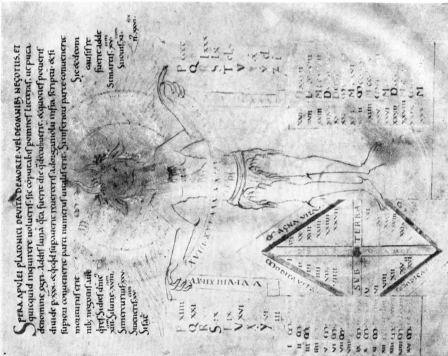

approx. 3:4

10 (b) 'Mors': MS. Bodley 579, fol. 50

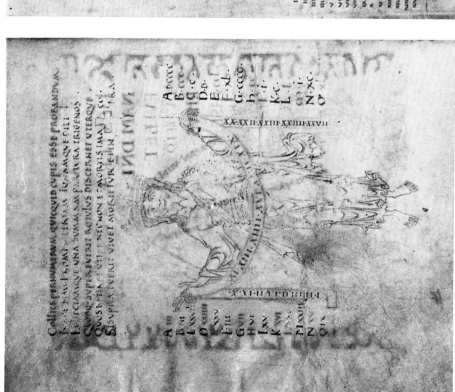

approx. 3:4

10 (a) 'Vita': MS. Bodley 579, fol. 49v

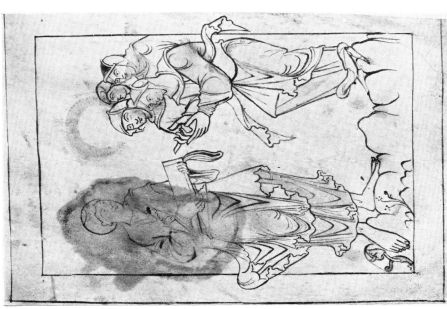

approx. 4:5

11 (b) St. Aldhelm with the nuns of Barking: MS. Bodley 577, fol. 1ᵛ

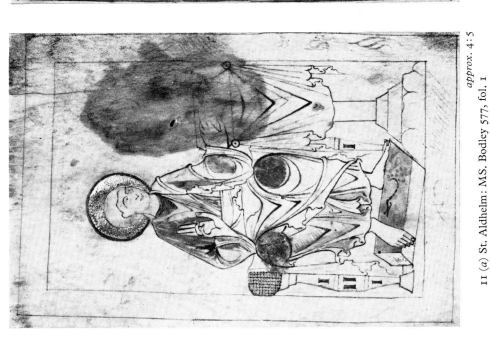

approx. 4:5

11 (a) St. Aldhelm: MS. Bodley 577, fol. 1

INNOMINE SCAE TRINITATIS. INCIPIT LIB II
EXOPVSCVLIS VEL INSTITVTIS CATHOLICORVM
PATRVM BREVITER EXCERPTVS QVIBVS MODIS
CVNCTA PER XPI GRATIA HVMANO
GENERI REMITTVNTVR PECCATA

TENIM INEXPOSITi
one sexu pyulmi cayyodon aic. Septem mo

12 (*a*) Initial 'V': MS. Bodley 718, fol. 24

approx. 4:5

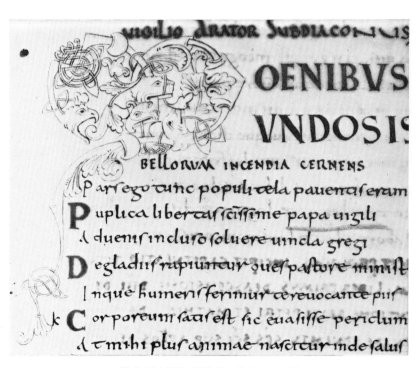

uisilio arator subdiaconus

OENIBVS
VNDOS I
BELLORVM INCENDIA CERNENS
P arr ego aunc populi aela pauenuf eram
P uplica liberaaf faiffime papa uigili
A duenif in duro foluere uincla gregi
D e gladiif rapiunaur suef paftore miniff
I nque humeri ferimur ae reuocance puf
k C orporeum faaif eft fic euaffe periclum
A am mihi pluf animae nafaar inde faluf

12 (*b*) Initial 'M': MS. Rawl. C. 570, fol. 2

uidelicet quaesupius cecinit·

OSTHAEC

i·tacuit·

PAVLISPER·OPTICVIT

p qm ·i· dolorem meu auiditatem· ·i· tranquilla sua aut mea·

ATQVEVBI·ATTENTIONEM·MEAM·MODESTA·TACI
dephendit coepit loqui· sicut inchoauit· ·i· minime extorto
pit cogn·u·
turnitate collegit sic exorsa est· Sipenitus ae
animi ·i·q̄litatem· t origines corporis
gritudinistuiae causas habitumque cognoui·
felicitatis procupiditate ·i· languet tis es·
fortunae prioris affectu desiderioq̄ tabescis; Ea
por fortuna intellectum·s·statum inaduersitate
componis t imaginaris·
statum Animi tui sicuttu tibi fingis mutatu per
pturbat s ego ·i·multiplices φ s·fostune h obscuritates t fa
colo
uertit; Intellego multiformes illius prodigi fucos·
·i·tadiu intelligo s hoib: ·i· decipe ·i· conatur
eteousq̄ cuhisquoseludere nititur blandissimam fa
s illius fostune donec habere uidetur ·i· conuertat t pturbat s illos
miliaritate· dumintolerabili dolore confundat·
cu sperat homo ut relinqtur abipsa s·fostune istabilitate c suetudine ·i·q̄n
quos insperata reliquerit; Cuius sinatura mores·
recordaris qd ualeat quadiu tecu fuit s·fostuna du tibi iocunda fu
prii
ac mertuum reminiscare nec habuisse te ineapulchru·

approx. 4:5

13. Initial 'P': MS. Auct. F. 1.15, fol. 16

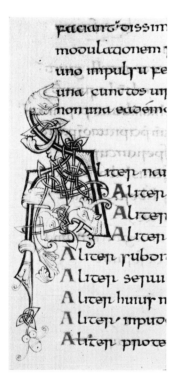

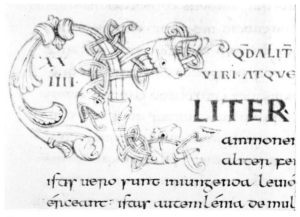

(b) approx. 4:5

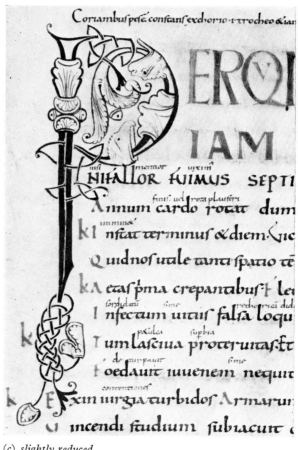

(a) slightly reduced

14 (a) Initial 'A': St. John's College, MS. 28, fol. 26 (b) Initial 'A': St. John's College, MS. 28, fol. 27 (c) Initial 'P': Oriel College, MS. 3, fol. 6

(c) slightly reduced

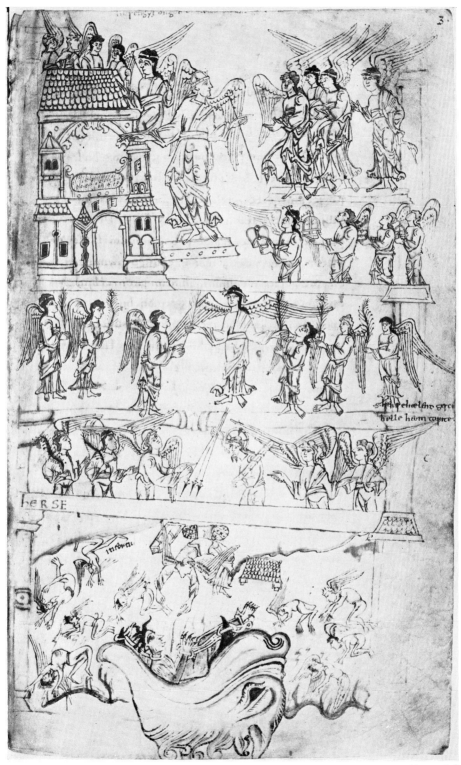

15. The rebellion of Satan: MS. Junius 11, p. 3

approx. 5:8

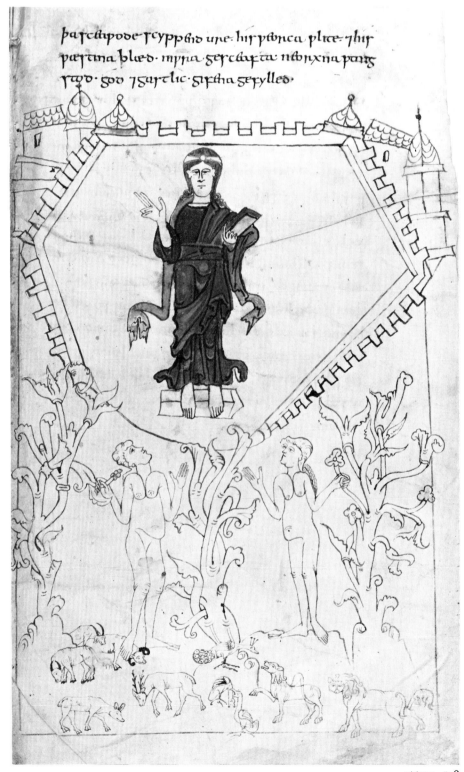

þar ætywde ſcyppend une· hiſ þ ona plice· þiſ
þæſtna blæd· mid ſa ge ſcæ þta· neð nx na þ arg
rwð· god· ſ ſ ar tlic· ſ iſ þa ge þylled·

approx. 5 : 8

16. God blessing Adam and Eve: MS. Junius 11, p. 11

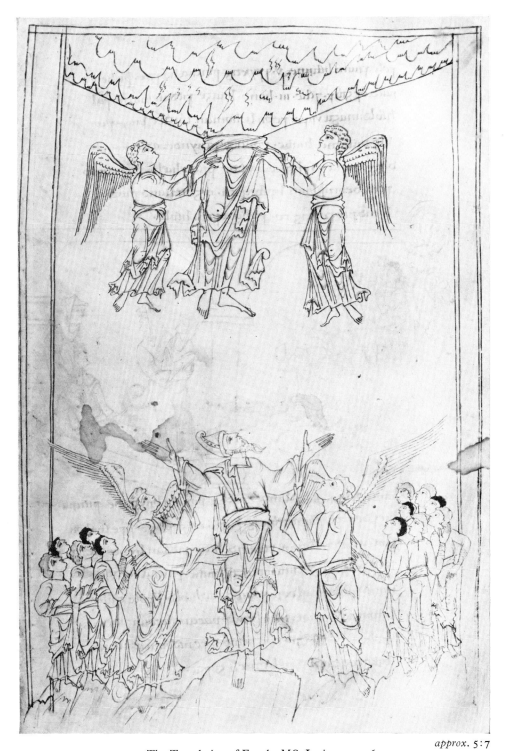

approx. 5:7

17. The Translation of Enoch: MS. Junius 11, p. 61

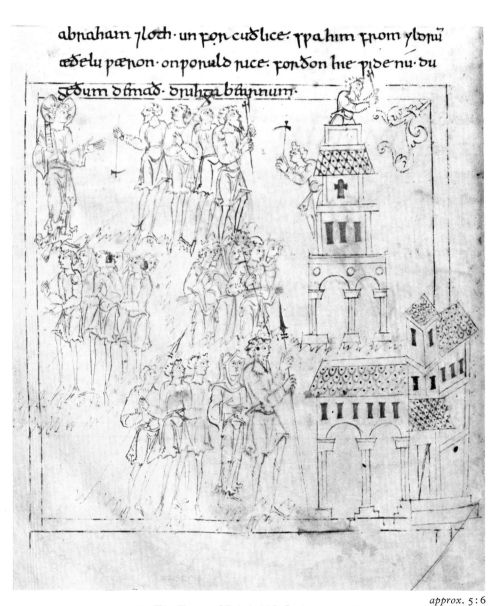

abraham ⁊ loth. un ꝼon cuðlice· ꝼpa him ꝼrom yloꝼu
æðelu pæꝼon· onponulð ꝛice· ꝛonðon hie ꝼiðe nu· ðu
ᵹeðum ðꝼmað· ðꝛuhᵹa bꝛynnum·

18. The Tower of Babel: MS. Junius 11, p. 82

approx. 5:6

he on þære ðline aytah ⁊ hiy bloð azeat zoð oð zalzan þuph hiy
zaytuy mazen foyþon men yceolon mælð zehpylce yeczan
opuhyeyþanc ðæðum ⁊ yeopeum haþ de he up oþ hæftuin
ham zelæedde up to eðle þænþe azan opulthey ðomay ⁊þe inþynnum
þunianzoton uy iy puloney leoht toplht onþyneð þamðe tala þenced.

19. Design for a repeating pattern: MS. Junius 11, p. 225

20. Sketches: MS. Junius 11, p. 230

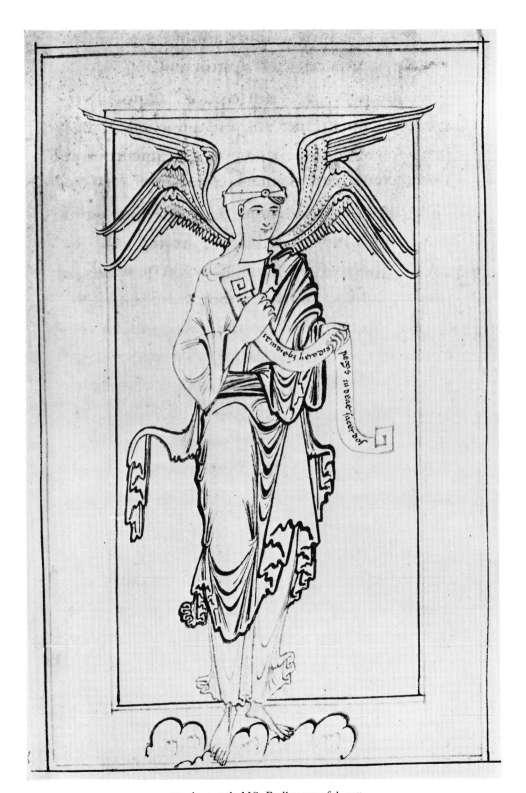

21. An angel: MS. Bodley 155, fol. 93ᵛ

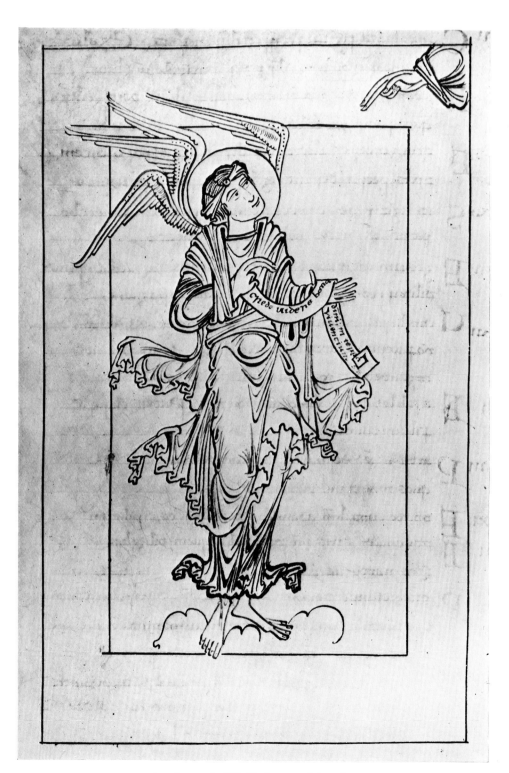

22. An angel: MS. Bodley 155, fol. 146ᵛ

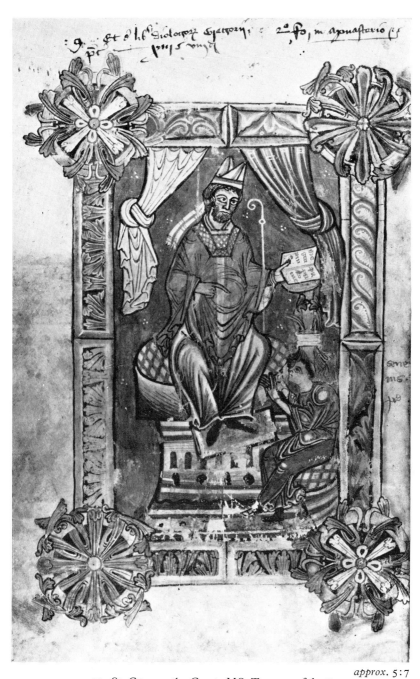

approx. 5:7

23. St. Gregory the Great: MS. Tanner 3, fol. 1ᵛ

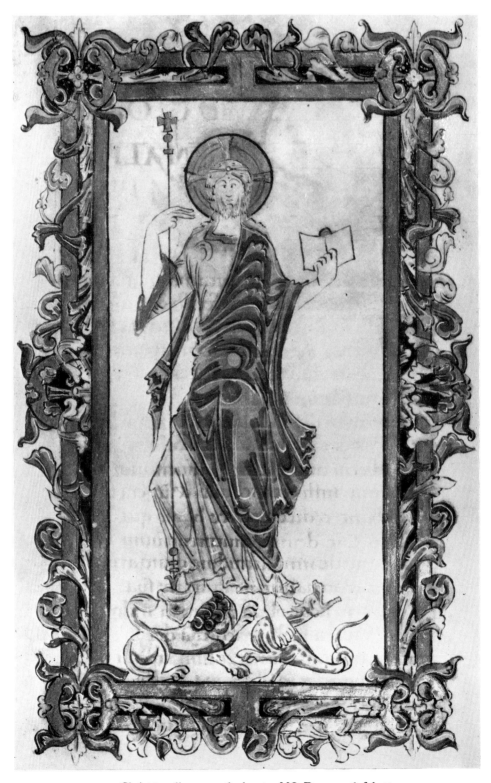

24. Christ treading upon the beasts: MS. Douce 296, fol. 40

(b) approx. 2:3

(a) approx. 5:8

25 (a) Initial 'B': MS. Douce 296, fol. 9 (b) Initial 'Q' with a figure fighting a dragon: MS. Douce 296, fol. 40v

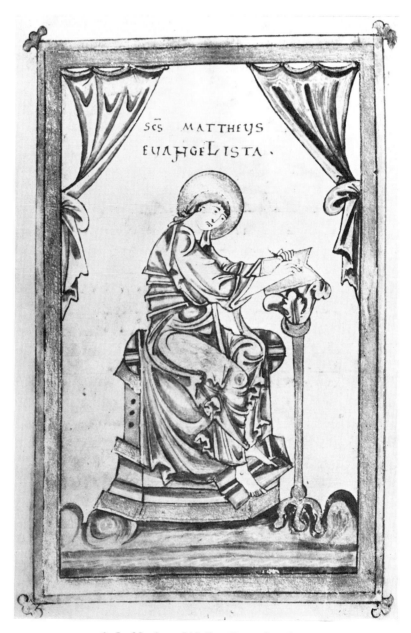

SCS MATTHEUS
EUAHGELISTA.

26. St. Matthew: MS. Lat. liturg. f. 5, fol. 3ᵛ

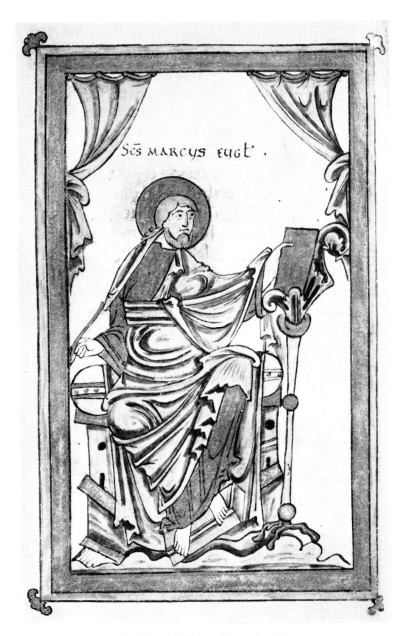

27. St. Mark: MS. Lat. liturg. f. 5, fol. 13ᵛ

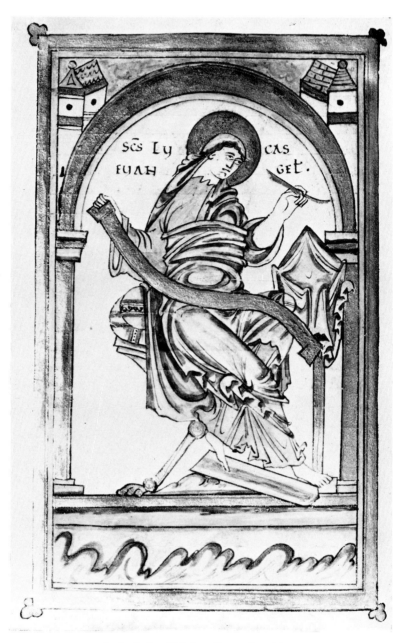

SĈS LẎ
ẼẎÃH

CAS
ĠET.

28. St. Luke: MS. Lat. liturg. f. 5, fol. 21ᵛ

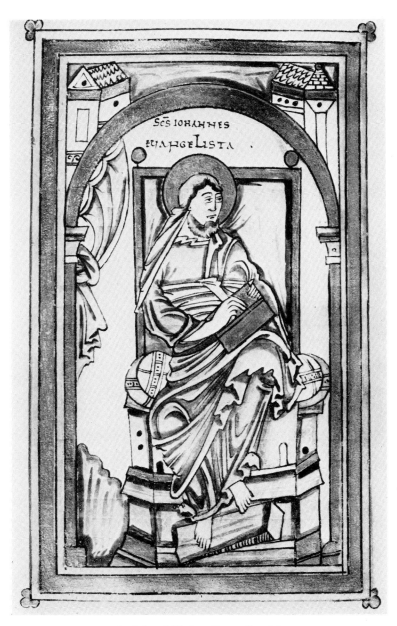

29. St. John: MS. Lat. liturg. f. 5, fol. 30ᵛ

INCIPIUNT TROPI DEADUENTU

DOMINI NRI HIESU XPISTI·

BENEdicta TUIS ABSIS

protectio seruis·

Adteleuaui p̄ uias̄·

Adte· Gloria ·ADREP·

ALmifico quondam perflatus fla

mine dauid· clarisonif xpo prompfit

hif uocibuf odaf· Adteleuaui· Sed

uirtute tua rutilanf inhonore trium-

phi· Neque ir· Quitempnunt fibi met

fua fubdere colla fuperbif· Etenim·

GR Uniuerfi quite expectant nonconfun

dentur domine· u Uiaf tuaf domine

notaf fac mi hi &femitaf tu af edo

ceme· Allc luia· Oftende nobif

30. Initial 'O': MS. Bodley 775, fol. 8

approx. 5:6

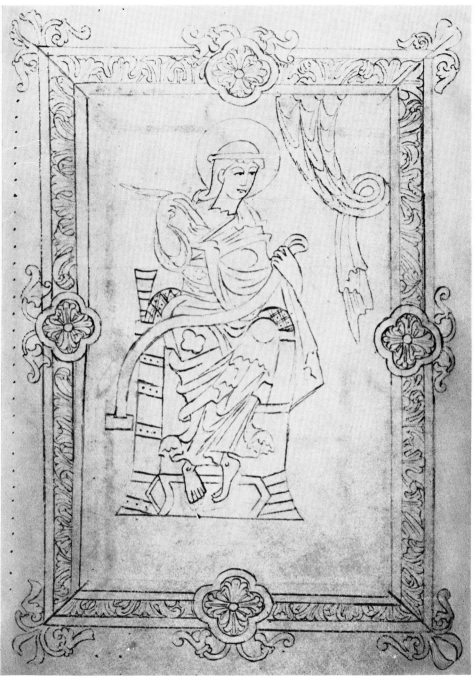

slightly reduced

31. St. Matthew: Wadham College, MS. 2, fol. 12v

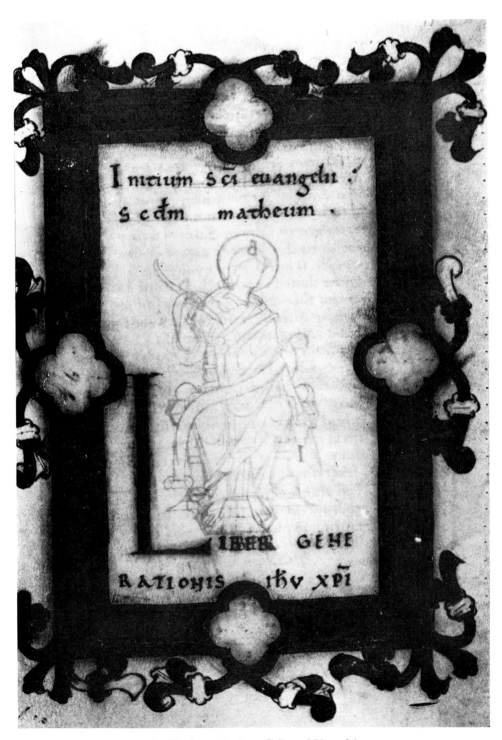

32. St. Matthew: Wadham College, MS. 2, fol. 13

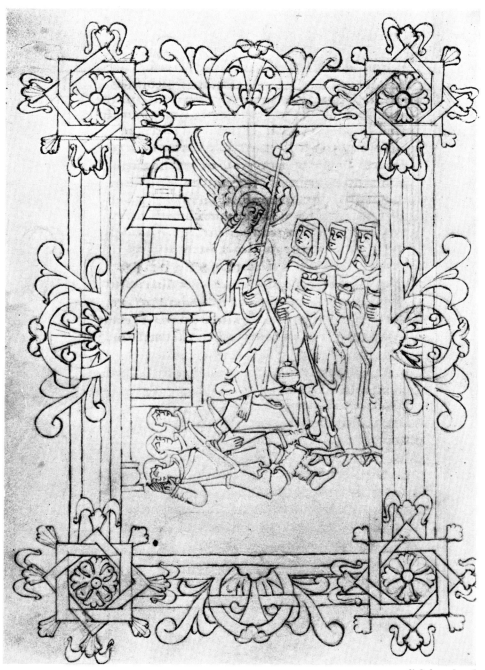

slightly reduced

33. The Maries at the Sepulchre: Wadham College, MS 2, fol. 104ᵛ

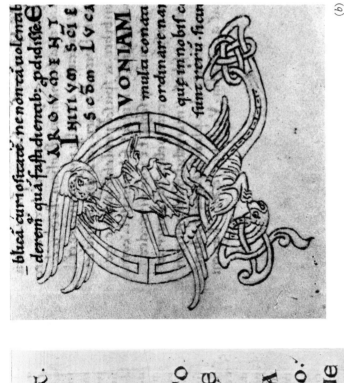

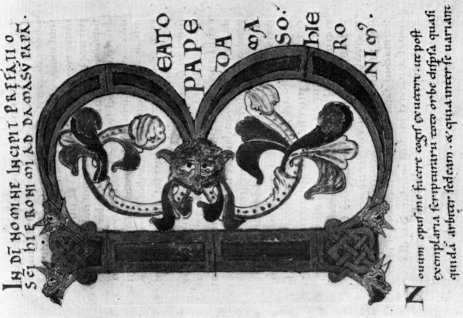

34 (a) Initial 'B'; Wadham College, MS. 2, fol. 3 (b) Initial 'Q'
with angel: Wadham College, MS. 2, fol. 67

(a) approx. 5:6

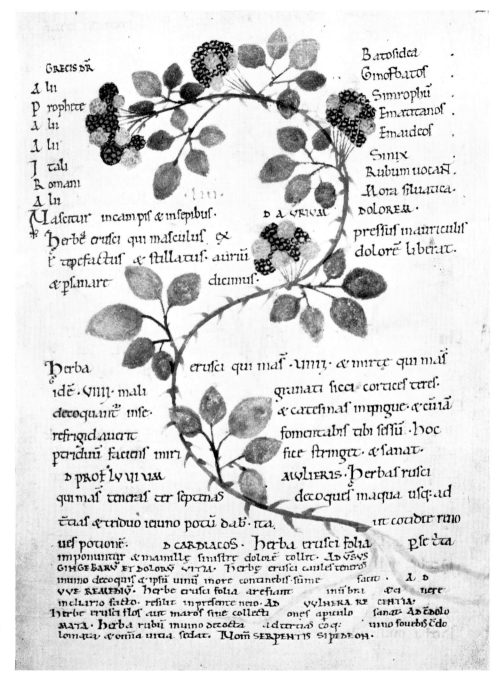

GRECIS DR

A lii
P rophete
A lii
A lii
J tali
R omani
A lii

Naſcitur incampis & inſepibus.

* herbe cruſci qui maſculuſ. &
t̄ tepefactuſ & ſtillatuſ. aurīū
& pſanare dicimuſ.

Batoſidea
Cinoſbatoſ
Simrophū
Emarananoſ
Emaudeoſ
Simix
Rubum uocan.
Mora ſiluatica
DOLOREM.
preſſuſ mauriculiſ
dolorē libat.

herba
idē. VIIII. mali
decoquant̄ inſe
refrigidauant
piduū faciēſ miri

D PROF LV VI VM
qui maſ teneraſ ter ſepanaſ

cruſci qui maſ. VIIII. & mirce qui maſ
granati ſicca corticeſ tereſ.
& cateſinaſ inpingue. & cūa
fomentabiſ tibi ſeſſū. hoc
fice ſtringet. & ſanat.
AVLIERIS. herbaſ ruſci
decoquet maqua uſq̄ ad

t̄caſ & triduo ieiuno pocū dab. ita.

it coudit ratio

ueſ potione. D CARDIACOS. herba cruſci folia
imponuntur & mamille ſiniſtre dolorē tollit. AD VSVS
GINGEBARV ET DOLORS VITRA. herbe cruſci cauleſ teneroſ
inuino decoquiſ & ipſū uinū more conuncbiſ ſume facit. Z D
VVE REMEDIV. herbe cruſci folia areſiant inū bri & a nere
inclutirio facto. reſilit inpreſente neio. AD VVLNERA RE CINTIA
herbe cruſci floſ aut maroſ ſine collecti oneſ apiculo ſanat AD ENDOLO
MATA. herba rubu inuino decocta adtertiaſ coq: uino ſouebiſ t̄do
lomatu & oniia uitia ſedat. Mom SERPENTIS SI PEDE OH.

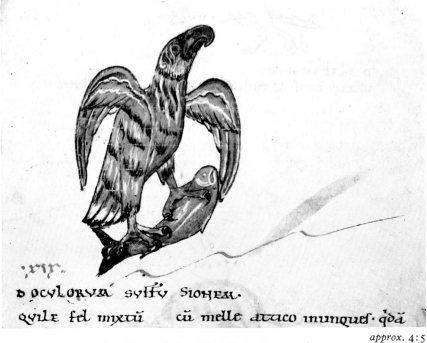

approx. 4 : 5

36 (*a*). The eagle (aquila): MS. Bodley 130, fol. 91ᵛ

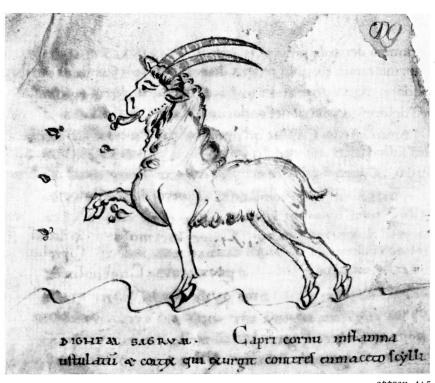

approx. 4 : 5

36 (*b*). Capricorn: MS. Bodley 130, fol. 89